STONE AND STEEL

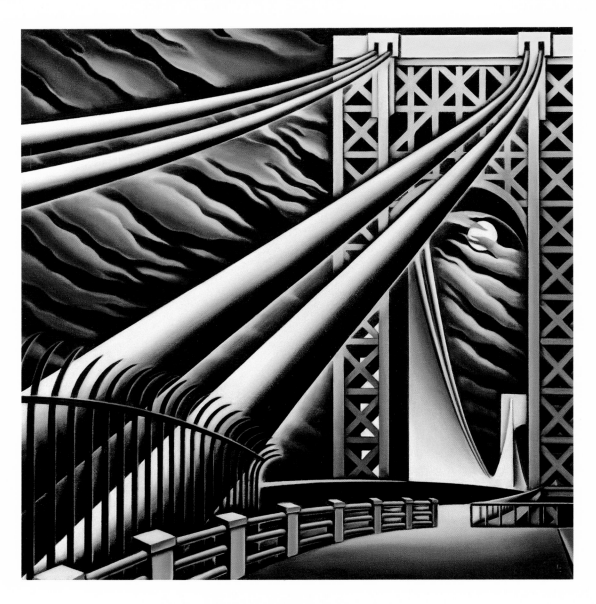

GEORGE WASHINGTON BRIDGE

Stone and Steel

Paintings & Writings Celebrating

THE BRIDGES OF NEW YORK CITY

Painted & Edited by

BASCOVE

DAVID R. GODINE
Publisher
BOSTON

For Michael, Lillian, and Leonard

First published in 1998 by
DAVID R. GODINE, *Publisher*
Box 450
Jaffrey, New Hampshire 03452

Library of Congress Cataloging-in-Publication Data
Stone and steel / edited by Bascove; [introduction by Mary Gordon].
p. cm.
ISBN 1-56792-081-0 (alk. paper)
1. Bridges—New York (State)—New York—Literary collections.
2. American literature—New York (State)—New York. 3. Bridges in art.
4. New York (N.Y.)—In art. I. Bascove.
PS509.B6876 1997
810.8´0356—dc2L 97-17832
CIP

First edition, January 1998
Printed in Hong Kong by C & C Offset

TABLE OF CONTENTS

ACKNOWLEDGMENTS

I am particularly grateful to Barbara Ball Buff and Jan Ramirez of the Museum of the City of New York, who inspired and encouraged this project.

Heartfelt thanks and sincere gratitude to all who shared in its progress: Jean Marcellino and Bernadette Evangelist, whose talent and generosity of spirit were indispensable in making order of the material; Mary McClean, Chase Twichell, Esther Kininmonth, and Mary Stewart Hammond, whose wise and knowledgeable suggestions of poets contributed an essential sensibility to this collection.

Special thanks to Sarah Jane Freymann, who believed in and supported this effort from the beginning; David R. Godine, whose passion and enthusiasm made it possible; Mary Gordon, who joined her exquisite voice to the other extraordinary contributors; and especially my husband, Michael Avramides, who in his determination that I get the most complete perspectives of my subjects, drove me to each bridge, in all kinds of weather, often several times, stood in the middle of highways filled with speeding cars, scouted hazardous abandoned walkways, and with great joy found a variety of ways to balance perilously from rooftops, reserve camera in hand—a true companion on every step of this journey.

INTRODUCTION

Manhattan is an island. For us who would have answered the question, "Where are you from," with the answer, "New York," concealing the shadow answer we hoped wouldn't have to come to light (Brooklyn, Queens, The Bronx, Long Island), it was the fortunate island, the island of the blessed. The object of desire that needed to be travelled to, although what had to be crossed was most importantly not, to us, literal, but metaphoric. Ideally, almost comically metaphoric! So the bridges that brought us to our heart's desire: the Queensboro, the Triborough, the George Washington, the Williamsburg, and most celebrated, the Brooklyn Bridge, represented to us all our possibilities. They embodied, with a solidity many of us had no interest in, because solidity was precisely what we were fleeing, our state of suspension, our sense of being on our way, of a great risk taking, of a landing on dry land almost too good to be true.

"You could sell him the Brooklyn Bridge." These words, of course, were always meant as an insult, but below them is the prudent person's envy of the dreamer, however hopeless his dreams. Bridges are about hope, and hope is of course joined to faith: you cannot believe without hope, and hope dies without the drier grounding of belief. In our time, bereft as we feel of hope and belief, can we imagine ourselves as builders of bridges? It's not surprising that the nineteenth century, particularly its latter half, was the great age of bridge building. It was a time when, often against or despite all the evidence, men (I use the excluding pronoun deliberately) believed that problems could be solved by their imagination, energy, good will, and by the marshalling of resources whose depletion was outside their reckoning. A river was not something uncrossable, but something to be worked with, worked on, tamed. Separation was not an inevitable sign of an irreducible, immutable human condition; it was a temporary state, and able to be overcome. Inertia was the product of a sad, dead age there was no need to be moored in; motion was the order of the day. Staying put was for losers, and it was a time when losers seemed an offense against the temper of the times.

Light, water, air: bridges are related to those unearthly elements at the same time that they

· 7 ·

must overcome them. They must not be drawn down into water; they must stand in and against air; their lights will make an operatic mockery of the tyranny of darkness. If they are not rooted in earth, if they are not partners with gravity, they will be the path not to dreams, but to foolish and ignoble death. Mathematics and poetry, the poetry of mathematics, the mathematics of poetry. Through calculations that cannot be wrong (but of course, they must occasionally be—made as they are by humans) bridges allow actuality to what began as dream. They require the folly of the dreamer joined to the engineer's life-giving marriage to fact: to stress and balance, and to all the weight and heaviness of earth.

And yet, we know by the lifting of our hearts when we look at them that they are always victorious. They can be nothing but triumphant; a failed bridge quickly joins the ranks of the invisible, what we avert our eyes from—ruin, failure. What would we call it? We would not call it a bridge. We would say it was once a bridge, or it tried to be a bridge. We would not use the present tense indicative, the easy form of the verb to be.

Light, air, and earth, and of course life and death. The romantic way out of life, the leap into nothing. I was once told by a friend in San Francisco that people who really mean to jump face into nothingness; those who will take up their lives again, face land. To choose death, the leap into death, in the face of so much triumph, is to assert the power of nothingness over the force of endeavor, to say, "All that you can do is a feather touch against my anguish; you cannot stop this flight of mine into all that you have stood against, away from all that you have staked your claim on, and have said you loved."

Sadness, too. Partings upon bridges, failed, or perfect, or impossible lovers, it is always lovers, parting upon bridges, not brothers and sisters, parents and not friends. Because a bridge is the locus of romance, not of the steady daily grind of duty (*pace* commuters), of the give and take of middle-ground human relations. Bridges are not the site of compromise. And not, really, of final loss. It is possible to cross the bridge and to cross back again, perhaps endlessly. It would be possible to stay forever on the bridge, situated precisely nowhere. Bridges give the lie to the curse of entrapment; a bridge is not the work of fate, nor the home ground of the fatalist.

There are over two thousand bridges in New York, some grand, some humble, workman-like crossings over unglamorous bodies of water (the Harlem River, the Gowanus Canal)—no less, for all that, conveyers of promise, of freedom, of achievement or release. There is one bridge, one of the most beautiful. Hell Gate, whose name suggests the opposite of hope and possibility. Its beauty was, for a time, in full view—or perhaps not, for we have rendered them invisible—of the insane and the criminal, the disenfranchised, inhabitants of the prison, the hospital, the potter's field. How Bascove's vision of its troubled waters reminds us that escape is not always successful, that bridges separate, as well as join!

What has Bascove seen when she has looked at bridges? What has she taken from them, and what added to them? She is a painter for whom geometry is a love story; she understands always that the bodiless perfection of pure form is always a product of a living body, defying, with its every breath, the line's immunity to time. She knows that we take along with us, on our most hopeful journeys, our dreams, our histories, our nightmares, and our madnesses. We are, in her paintings, children revelling in stark primary colors, colors chilled or heated by our fevers or delights. She is a woman looking at bridges, which have always been the dreamwork and workplace of men. She has staked her claim to a vision no one told her she was born to, and yet of course she was born to it. The controlled wildness, the combination of menace and safety that have always marked her work find a perfect subject in bridges, whose inspiration is nature, but which defy nature; enablers of travel that appear to be still and yet tremble and sigh, shudder, with the secret, terrifying force of all great lovers.

To match the vision of her eye, she has found words of poets and prose writers that embody in language all the yearnings and the contradictions bridges suggest to our imaginations. She presents us with a vibrant array of images, from the down-to-earth to the purely visionary, from the rooted to the most abstract. This is a New York book, a book of promise and of life, a life of hope and danger and stability, a vessel that contains within itself the possible and the impossible, and the mutations and transformations of one to the other.

—MARY GORDON

· 9 ·

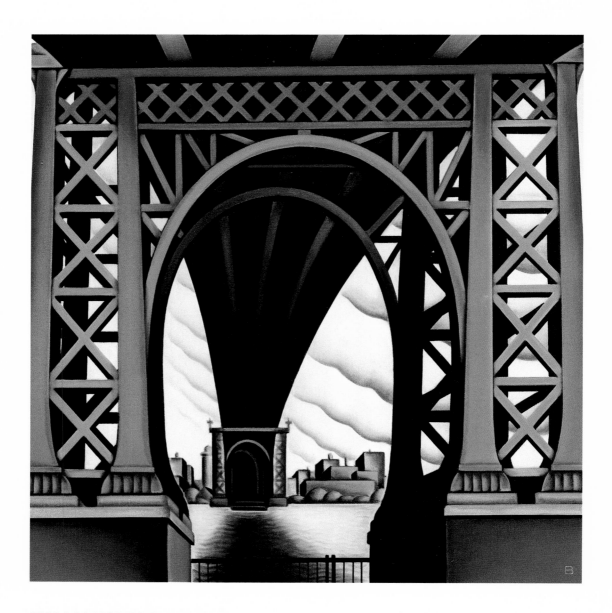

WILLIAMSBURG BRIDGE

THE MAGIC OF THE WILLIAMSBURG

"I like the Williamsburg Bridge."

That's what I always tell the cab driver when I'm leaving New York. I say the same thing when I've landed at LaGuardia or JFK, when I've come home. I've said it many times since my first boss in New York, that sharp-tongued, brittle gallery owner with the slash of white in her honey hair, told me, "Always take the Williamsburg. It's quicker." Characteristically, she might have added: "There are no tolls."

The Williamsburg isn't majestic and romantic like some of Manhattan's other bridges, but for me, it confirms my status as a New Yorker. No tourist asks for the Williamsburg. It's not a magical-looking bridge, but it does perform miracles: getting me to LaGuardia and checked-in in twenty minutes.

So for two decades, I've always said, "I like the Williamsburg." I say it tentatively, hoping the driver is experienced, hoping that traffic isn't clogging it, hoping that it hasn't fallen into the river.

Right now in 1996, they're still working on the Williamsburg. There's a number you can call to check the progress and how traffic is flowing. Sometimes the advice given is that the best alternative to the Williamsburg is the Williamsburg. For me there is no alternative.

—KAREN CHAMBERS

THE RIVER THAT IS EAST

I

Buoys begin clanging like churches
And peter out. Sunk to the gunwhales
In their shapes tugs push upstream.
A carfloat booms down, sweeping past
Illusory suns that blaze in puddles
On the shores where it rained, past the Navy Yard,
Under the Williamsburg Bridge
That hangs facedown from its strings
Over which the Jamaica Local crawls,
Through white-winged gulls which shriek
And flap from the water and sideslip in
Over the chaos of illusions, dangling
Limp red hands, and screaming as they touch.

2

A boy swings his legs from the pier,
His days go by, tugs and carfloats go by,
Each prow pushing a whitecap. On his deathbed
Kane remembered the abrupt, missed Grail
Called Rosebud, Gatsby must have thought back
On his days digging clams in Little Girl Bay

In Minnesota, Nick fished in dreamy Michigan,
Gant had his memories, Griffeths, those
Who went baying after the immaterial
And whiffed its strange dazzle in a blonde
In a canary convertible, who died
Thinking of the Huck Finns of themselves
On the old afternoons, themselves like this boy
Swinging his legs, who sees the *Ile de France*
Come in, and wonders if in some stateroom
There is not a sick-hearted heiress sitting
Drink in hand, saying to herself his name.

3
A man stands on the pier.
He has long since stopped wishing his heart was full
Or his life dear to him.
He watches the snowfall hitting the dirty water.
He thinks: Beautiful. Beautiful.
If I were a gull I would be one with white wings,
I would fly out over the water, explode, and
Be beautiful snow hitting the dirty water.

4

And thou, River of Tomorrow, flowing . . .
We stand on the shore, which is mist beneath us,
And regard the onflowing river. Sometimes
It seems the river stops and the shore
Flows into the past. Nevertheless, its leaked promises
Hopping in the bloodstream, we strain for the future,
Sometimes even glimpse it, a vague, scummed thing
We dare not recognize, and peer again
At the cabled shroud out of which it came,
We who have no roots but the shifts of our pain,
No flowering but our own strange lives.

What is this river but the one
Which drags the things we love,
Processions of debris like floating lamps,
Towards the radiance in which they go out?
No, it is the River that is East, known once
From a high window in Brooklyn, in agony—river
On which a door locked to the water floats,
A window sash paned with brown water, a whisky crate,
Barrel staves, sun spokes, feathers of the birds,
A breadcrust, a rat, spittle, butts, and peels,
The immaculate stream, heavy, and swinging home again.

—GALWAY KINNELL

THE BRIDGE

Between now and now,
between I am and you are,
the word *bridge*.

Entering it
you enter yourself:
the world connects
and closes like a ring.

From one bank to another,
there is always
a body stretched:
a rainbow.

I'll sleep beneath its arches.

 —OCTAVIO PAZ

UNDER THE WILLIAMSBURG BRIDGE

1

I broke bread
At the riverbank,
I saw the black gull
Fly back black and crossed
By the decaying Paragon sign in Queens,
Over ripped water, it screamed
Killing the ceremony of the dove,
I cried those wing muscles
Tearing for life at my bones.

2

Tomorrow,
There on the Bridge,
Up in some riveted cranny in the sky,
It is true, the great and wondrous sun will be shining
On an old spider wrapping a fly in spittle-strings.

—GALWAY KINNELL

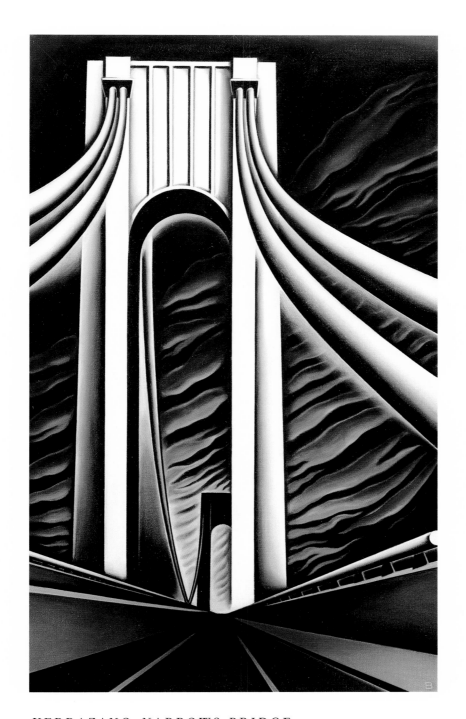

VERRAZANO-NARROWS BRIDGE

BEFORE THE BRIDGE: A STORY

I.

"Too bad they didn't know the house was built on swamp,"
Joe Reese laughed to Grace Vance one Sunday after the rain,
my parents in the backyard bailing out the basement,
us kids feet-up on a pile of socks.

The house leaned. The mud-sod oozed.

Stupid guineas.
These people from Brooklyn.
Greenhorns my mother called the ones just over.
Pierced ears, vegetable smells.
Dense mobs mooing and shoving off the Staten Island ferry.

We came over before the bridge went up,
no other Italians
except the Dominicas who owned the grocery.
Sarah Dominica who everyone said had spiders
in that teased black hair. *A rat's nest*
so high it knocked the cake display sign over the register.
I wondered if it came off at night, the spiders
and what else tangled in her hair.
I dreamed of Sarah Dominica's hair, breeding
spiders at the roots; her brother Joe who lost

his arm leaning out a bus,
wore a long-sleeved shirt knotted at the wrist,
packed sandwiches with his good right arm.
"Italians," Grace said, "and more coming over with the bridge going up."

2.
The bridge was going up—the Verrazano-Narrows—
the longest, highest, suspension
bridge in the world,
and Thomas Fleming's father worked on it.
Not at the top, where the Indians worked,
the one who slipped, fell to the harbor.
"Indians love heights," my father said.
"They're made to work on bridges."
I thought of him falling, drowning,
how they said he must have died before he hit.
I wondered if Indians loved water too,
what made them want to work up high.
"Staten Island must be wild," I said,
"if there's still Indians here."
"They're different now," my mother said.
"No more feathers and beads."

3.

When the builders came to Great Kills, rats ran down Hylan Boulevard.
I slogged through mud with Carol Keane, Gus Eklund, and my brother Gregg,
hunting for arrowheads, back in the woods
where new developments were going up.
All I ever found were pointy rocks.
We slogged and climbed and filled our pockets,
then one by one
jumped from the peaks of the high dirt piles.
"Geronimo," Carol yelled and jumped.
"Geronimo," Gus yelled and jumped.
"Geronimo," I yelled and stood, too scared to jump until my brother shoved me and I fell,
belly-whopping the swampy mud.
"Look out for rats," Gus yelled.
"Crawl like a pig," Carol yelled.
"A guinea pig! A guinea pig !" my brother screamed, leaping
down, pounding his mouth, whooping around and
around me rooting in the mud.

—DONNA MASINI

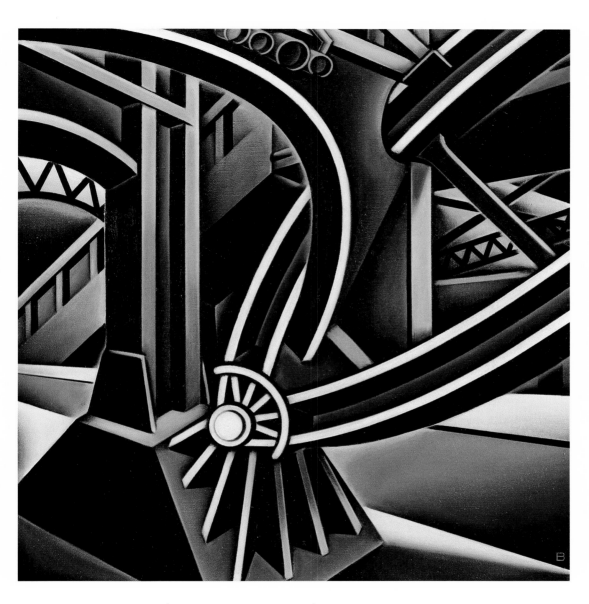

HINGED BRIDGE (125TH & VIADUCT)

UNDER THE VERRAZANO

In the summer of 1974, the *S.S. France* made its last transatlantic voyage. I bought a student ticket, *Destination: New York*. Morning after morning, I stood on deck and greeted blue sky and blue sea or grey sky and grey sea and set my watch back one gentle hour.

One day, I discovered America. I gripped the rail and watched as the Verrazano Bridge loomed closer and closer. Named for a navigator, the Verrazano was solid, not some wanton drawbridge that opens on demand. Was this a showdown? Would our red and black smokestacks collide with its girth and girders?

Gulls cried and the *S.S. France* sounded its baritone horn. With grace and majesty, the ship slipped beneath the bridge, forming a fleeting cross. I stared up at the expanse of steel, the downpour of cable.

Still ahead, small and green and distant, the Statue of Liberty waved in discreet welcome. I waved back.

It was my senior year of high school. I had gone off a girl and was returning a woman. That bridge was behind me. I was almost home.

—CAROL WESTON

IN SUSPENSE

at the Verrazano-Narrows Bridge

The composition of many particulars
Held the broad promise of our beginning
And so we set out calmly into the sky,
Out over sheer space and distant waters
Where other travellers had found harbor;
It was the gothic grandeur, the bright towers,
By which we knew the magnitude of our attempt,
Rushing forward into the expanding light.
The structure of our adventure, the road
We went by, protected us from the view
Beneath us, and it was the monumental
Objects, distant caricatures of themselves,
Which tried to occupy our attention.
Having come so far, we reached the summit:
A surprise, we hadn't been paying attention
To much besides a perception of ourselves
As puny and audacious, caught in a monumental
Undertaking; but now the panoramic view
Of our accomplishment, the end of the road,
Presented itself in the soft, reflected light.
We felt, of course, elevated in our attempt,
Inspired by the reach of the last aspiring tower,
Felt fulfilled in the wish each of us harbors
To journey and return safely off the waters;
And so we were set down out of the sky
According to the prescriptions of our beginning
Into a difficult place, though we weren't particular.

—GEORGE BRADLEY

Building a bridge is like combat; the language is of the barracks, and the men are organized along the lines of the noncommissioned officers' caste. At the very bottom, comparable to the Army recruit, are the apprentices—called "punks." They climb catwalks with buckets of bolts, learn through observation and turns on the tools, occasionally are sent down for coffee and water, seldom hear thanks. Within two or three years, most punks have become full-fledged bridgemen, qualified to heat, catch, or drive rivets; to raise, weld, or connect steel—but it is the last job, connecting the steel, that most captures their fancy. The steel connectors stand highest on the bridge, their sweat taking minutes to hit the ground, and when the derricks hoist up new steel, the connectors reach out and grab it with their hands, swing it into position, bang it with bolts and mallets, link it temporarily to the steel already in place, and leave the rest to the riveting gangs.

Connecting steel is the closest thing to aerial art, except the men must build a new sky stage for each show, and that is what makes it so dangerous—that and the fact that young connectors sometimes like to grandstand a bit, like to show the old men how it is done, and so they sometimes swing on the cables too much, or stand on unconnected steel, or run across narrow beams on windy days instead of straddling as they should—and sometimes they get so daring they die.

Once the steel is in place, riveting gangs move in to make it permanent. The fast, four-man riveting gangs are wondrous to watch. They toss rivets around as gracefully as infielders driving in more than a thousand a day, each man knowing the others' moves, some having

traveled together for years as a team. One man is called the "heater," and he sweats on the bridge all day over a kind of barbecue pit of flaming coal, cooking rivets until they are red—but not so red that they will buckle or blister. The heater must be a good cook, a chef, must think he is cooking sausages not rivets, because the other three men in the riveting gang are very particular people.

Once the rivet is red, but not too red, the heater tong-tosses it fifty, or sixty, or seventy feet, a perfect strike to the "catcher," who snares it out of the air with his metal mitt. Then the catcher relays the rivet to the third man, who stands nearby and is called the "bucker-up"—and who, with a long cylindrical tool named after the anatomical pride of a stud horse, bucks the rivet into the prescribed hole and holds it there while the fourth man, the riveter, moves in from the other side and begins to rattle his gun against the rivet's front end until the soft tip of the rivet has been flattened and made round and full against the hole. When the rivet cools, it is as permanent as the bridge itself.

Each gang—whether it be a riveting gang, connecting gang, or raising gang—is under the direct supervision of a foreman called a "pusher." (One night in a Brooklyn bar, an Indian pusher named Mike Tarbell was arrested by two plainclothes men who had overheard his occupation, and Tarbell was to spend three days in court and lose $175 in wages before convincing the judge that he was not a pusher of dope, only of bridgemen.)

—GAY TALESE

IN THE HELLGATE WIND

January ice drifts downriver
thirty years below the dizzy bridge. Careening traffic
past my narrow walk
tells me warm news of disaster. Sun lies
low, can't thaw my lips. I know
a hand's breadth farther down could freeze me solid
or dissolve me beyond reassembling.
Experts jostle my elbow.
They call my name.
My sleeves wear out from too much heart.

When I went back to pick up my life
the habit fit strangely. My hair escaped.
The frigidaire worked hard while I slept my night
before the cold trip home.
Roots of that passage go deeper than a razor
can reach. Dead lights
in the station end access by rail.
I could stand still to fail the danger,
freeze a slash at a time, altitude for anaesthetic.
Could follow my feet in the Hellgate wind
wherever the dance invites them.

The pure leap I cannot take stiffens downstream,
a millrace churned to murder.
The siren cries
at my wrist, flicks my throat, routine
as the river I cross over.

——MADELINE DEFREES

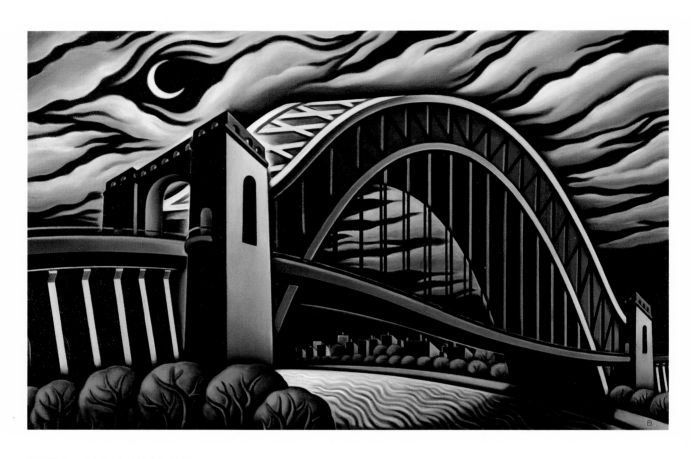

HELL GATE BRIDGE

LAST EXIT BEFORE BRIDGE

Memory. That place we invent where
what never happened in quite that way
keeps happening. Keeps
happening.

There was once a young woman lying
at the side of a highway. So public and
was she a woman like you you didn't want
to know. A "traffic accident,"

and her car crushed "like an accordion,"
skidded sideways against the highway
divider. Uniformed men, an ambulance,
one of those ceremonial occasions

where four lanes of traffic are funneled
into three, red flares, sirens, a migration
of vehicles inching westward at the blind-
ing hour of 6 p.m. when the sun blazes

off chrome and windshields and everyone
was staring at the young woman whom
they couldn't see lying in shattered glass
weeping, or bleeding, or is she dead?—

about to be lifted onto a stretcher but
it's too insignificant to be noted
in the newspaper and no one will remember
it as it happened—just east

of the great Tappan Zee Bridge where
shattered glass is promiscuous and if
there's an accident it's another crushed car
and if there's blood on the pavement

it's someone else's blood, or merely
oil stains. So it's pointless to return
one day years later pointing, *There.
There.* Spiky weeds the color of grit,

concrete, no urgency even from the sun,
no memory except where, when the wind-
shield smashed, your head and that certainty
came so perfectly together.

<div align="right">

—JOYCE CAROL OATES

</div>

BRIDGE THROUGH MY WINDOW

In-curve scooped out and necklaced with light
burst pearls stream down
my outstretched arms to earth.
Oh bridge my sister bless me
before I sleep
the wild air is lengthening
and I am tried
beyond strength or bearing
over water.

Love, we are both shorelines
a left country where time suffices
and the right land
where pearls roll into earth
and spring up day.
Joined
our bodies make a passage
without merging
as this slim necklace
is anchored into night.

And while the we conspires
to make secret its two eyes
we search the other shore
for some crossing home.

—AUDRE LORDE

IN LIEU OF THE LYRE

One debarred from enrollment at Harvard,
may have seen towers and been shown the Yard—
animated by Madame de Bouffiers' choice rhymes:
Sentir avec ardeur: with fire; yes, with passion;
rime-prose revived also by word-wizard Achilles—
 Dr. Fang.

The *Harvard Advocate*'s select formal-informal
invitation to Harvard made grateful, Brooklyn's (or Mexico's)
 ineditos—
one whose "French aspect" was invented by
 Professor Levin,
a too outspoken outraged refugee from clichés particularly,
 who was proffered redress
 by the Lowell House Press—
Vermont's Stinehour Press, rather. (No careless statements
to Kirkland House; least of all inexactness in quoting a fact.)

 To the *Advocate, gratia sum*
 unavoidably lame as I am, verbal pilgrim
like Thomas Bewick, drinking from his hat-brim,
drops spilled from a waterfall, denominated later by him
 a crystalline Fons Bandusian miracle.

It occurs to the guest—if someone had confessed it in time—
that you might have preferred to the waterfall, pilgrim and
 hat-brim,
 a valuable axiom such as
"a force at rest is at rest because balanced by some other force,"
 or "catenary and triangle together hold the span in place"
 (of a bridge),
 or a too often forgotten surely relevant thing, that Roebling cable
 was invented by John A. Roebling.

 These reflections, Mr. Davis,
 in lieu of the lyre.

 —MARIANNE MOORE

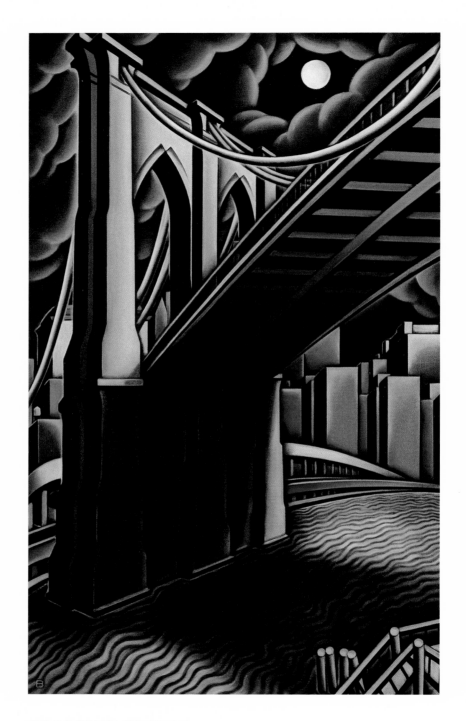

BROOKLYN BRIDGE

STEAMROLLER

Picking his teeth he walked through the grimydark entrance to Brooklyn Bridge. A man in a derby hat was smoking a cigar in the middle of the broad tunnel. Bud brushed past him walking with a tough swagger. I dont care about him; let him follow me. The arching footwalk was empty except for a single policeman who stood yawning, looking up at the sky. It was like walking among the stars. Below in either direction streets tapered into dotted lines of lights between square blackwindowed buildings. The river glimmered underneath like the Milky Way above. Silently smoothly the bunch of lights of a tug slipped through the moist darkness. A car whirred across the bridge making the girders rattle and the spiderwork of cables thrum like a shaken banjo.

When he got to the tangle of girders of the elevated railroads of the Brooklyn side, he turned back along the southern driveway. Dont matter where I go, cant go nowhere now. An edge of the blue night had started to glow behind him the way iron starts to glow in a forge. Beyond black chimneys and lines of roofs faint rosy contours of the downtown buildings were brightening. All the darkness was growing pearly, warming. They're all of em detectives chasin me, all of em, men in derbies, bums on the Bowery, old women in kitchens, barkeeps, streetcar conductors, bulls, hookers, sailors, longshoremen, stiffs in employment agencies . . . He thought I'd tell him where the ole man's roll was, the lousy bum . . . One on him. One on all them goddam detectives. The river was smooth, sleek as a bluesteel gun-barrel. Dont matter where I go; cant go nowhere now. The shadows between the wharves and the buildings were powdery like washingblue. Masts fringed the river; smoke, purple chocolate-color fleshpink climbed into light. Cant go nowhere now.

—JOHN DOS PASSOS

BROOKLYN BRIDGE

From the start, a matter of life and death:
the maker and his son lost to the river
their bridge would hold down—one struck by a ferry

the other by caisson bends—young Roebling's wife
learning math to redeem the family prophecy:
"It will be beautiful." And so it was, and is,

corseted to brace not merely horsecars,
but trucks. Now, the sky vast after dense buildings,
I wander under Gothic towers and watch

trapezoids spring skyward, spun wire ropes
quivering in sunlight. All around me
today like dancers stepping to unknown partners,

men and women travel east to Brooklyn,
set-jawed, some with kids in strollers,
then meet and sidle past those striding west.

"CYCLISTS DISMOUNT," an unseen caller shouts
and bikers obey. The crowd breaks for a woman
who lugs a canvas. Buckling some, she tacks

into the wind, not letting go. A man
carries roses, blooms pointed down. Some wild hope
in their striding cries out "It will be beautiful,"

and raises ghosts: Where walkway meets the road,
a vision of my grandmother in 1920,
belled skirt, braided red hair. She slithers under

her stalled Ford and out again, tarred black,
then cranks the engine. The cargo, prints
she's engraved on woodblocks with pen-like

gouges kept on shelves, riling my grandfather
until he uttered "Flora!" twice, and cursed
the inky floors, then tromped out, slammed the door.

At twelve she'd walked the bridge to mark shirt collars
in a factory. Married young, she yearned
to create *black* collars: she saw waves and sea

reversed to hazard what would be when wood
was pressed to paper, dreams caught in intaglio.
She drove her work through tall cathedral windows

past rude stares, to show it in "the city,"
smoothing a crumpled New York drivers' license,
one of the first earned by a woman, and bearing

four invisible words: "It will be beautiful."
She built no bridge, but crossed this steel
and sand-colored granite arched over schooners

that killed before it joined, that said it's not
just striving, but the risk. With the fixed gaze
of one drawn to hard tasks, she finds me, frowns,

slides into the Ford and rattles on.
Now, seeing caissons planted in the riverbed,
firm as punctuation, I trek the arch

in wonder. On the Manhattan turn-off,
a sign reads: "BROOKLYN BRIDGE, THE LEFT LANE ONLY."
Once you're in that lane, you can't turn back.

—GRACE SCHULMAN

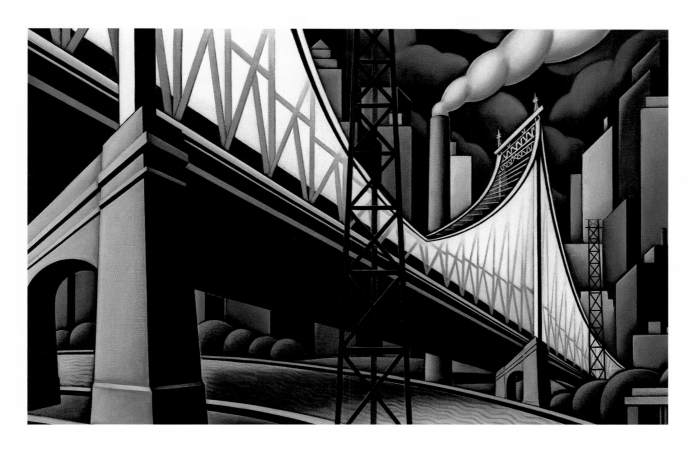

QUEENSBORO BRIDGE

OVER THE GREAT BRIDGE . . .

Over the great bridge, with the sunlight through the girders making a constant flicker upon the moving cars, with the city rising up across the river in white heaps and sugar lumps all built with a wish out of non-olfactory money. The city seen from the Queensboro Bridge is always the city seen for the first time, in its first wild promise of all the mystery and the beauty in the world.

—F. SCOTT FITZGERALD

A GLANCE FROM THE BRIDGE

Letting the eye descend from reeking stack
And black façade to where the river goes,
You see the freeze has started in to crack
(As if the city squeezed it in a vice),
And here and there the limbering water shows,
And gulls colonial on the sullied ice.

Some rise and braid their glidings, white and spare,
Or sweep the hemmed-in river up and down,
Making a litheness in the barriered air,
And through the town the freshening water swirls
As if an ancient whore undid her gown
And showed a body almost like a girl's.

—RICHARD WILBUR

SONNET XXXVII

Believe, if ever the bridges of this town,
Whose towers were builded without fault or stain,
Be taken, and its battlements go down,
No mortal roof shall shelter me again;
I shall not prop a branch against a bough
To hide me from the whipping east or north,
Nor tease to flame a heap of sticks, who now
Am warmed by all the wonders of the earth.
Do you take ship unto some happier shore
In such event, and have no thought for me,
I shall remain; to share the ruinous floor
With roofs that once were seen far out at sea;
To cheer a mouldering army on the march . . .
And beg from spectres by a broken arch.

—EDNA ST. VINCENT MILLAY

BRIDGES AND AIR

Once two trees' boughs
we wove into bedsprings
to meet over a river.
Once in a desert

caravan, two weeks passed
while Who Goes First?
got talked out and tried.
Once we pulled up our feet

and held our breath.
The fret can't fail, can.
Every bridge has its child
ghosts in the supports,

their pipes wavering
as the bricks set,
new shoes and hat for luck,
whatever they never lived to get.

The strongest bond,
the biggest sacrifice.
Science swears bridges stand
without it, the arrow

arched into the sun
marking where and how
and who to kill, all strength
drawn from the muffled cries.

But in a moment of bridge,
the blue yawns wide.

—TERESE SVOBODA

· 43 ·

Sometimes Tom walked alone to the head of the Queensboro Bridge, drawn by a mysterious power like his early fascination with the El. The bridge leaped some sixty feet above him, a mass of black crossed steel trusses, supported by heavy black stone towers that might vie with kings' tombs and medieval châteaux in their size and height. Tom loitered under the shadows, a tiny figure by comparison, wearing a loose sweater. He looked up. He saw that the bridge had the sweep of the sea, the grace and strength of a great work of art, the independence and pride of a beautiful woman, the leaping power of a leopard. The steel tower rising solid into the clouds must have been a hundred and twenty feet high from the ground. Traffic went on, trucks; street cars, automobiles, thousands of tons passing over it, and the bridge received them and did not even tremble. The bridge was a product of the human mind, impossible in any other civilization. If it had been created a thousand years ago, it would have become renowned as the greatest single wonder of the world, greater in size than the Pyramids, more wonderful than the Leaning Tower of Pisa, more majestic than the palaces of Assyrian kings.

Tom looked at it with puckered brow, admiring it and not understanding it. The bridge contained a mystery, a secret of human knowledge in a vast realm that he did not understand. There were so many things he wanted to study and understand, and he hated it that there were things he did not understand. The bridge itself became a symbol of the power of the age of machines and what makes the wheels of modern civilization turn.

—LIN YUTANG

Cut off as I am, it is inevitable that I should sometimes feel like a shadow walking in a shadowy world. When this happens I ask to be taken to New York City. Always I return home weary but I have the comforting certainty that mankind is real flesh and I myself am not a dream.

In order to get to New York from my home it is necessary to cross one of the great bridges that separates Manhattan from Long Island. The oldest and most interesting of them is the Brooklyn Bridge, built by my friend, Colonel Roebling, but the one I cross oftenest is the Queensborough Bridge at 59th Street. How often I have had Manhattan described to me from these bridges! They tell me the view is loveliest in the morning and at sunset when one sees the skyscrapers rising like fairy palaces, their million windows gleaming in the rosy-tinted atmosphere.

I like to feel that all poetry is not between the covers of poetry books, that much of it is written in great enterprises of engineering and flying, that into mighty utility man has poured and is pouring his dreams, his emotions, his philosophy. This materializing of his genius is sometimes inchoate and monstrous, but even then sublime in its extravagance and courage. Who can deny that the Queensborough Bridge is the work of a creative artist? It never fails to give me a poignant desire to capture the noble cadence of its music. To my friends I say:

> *Behold its liberal loveliness of length—*
> *A flowing span from shore to shore,*
> *A brimming reach of beauty matched with strength,*
> *It shines and climbs like some miraculous dream,*
> *Like some vision multitudinous and agleam,*
> *A passion of desire held captive in the clasp of vast utility.*

—HELEN KELLER

· 45 ·

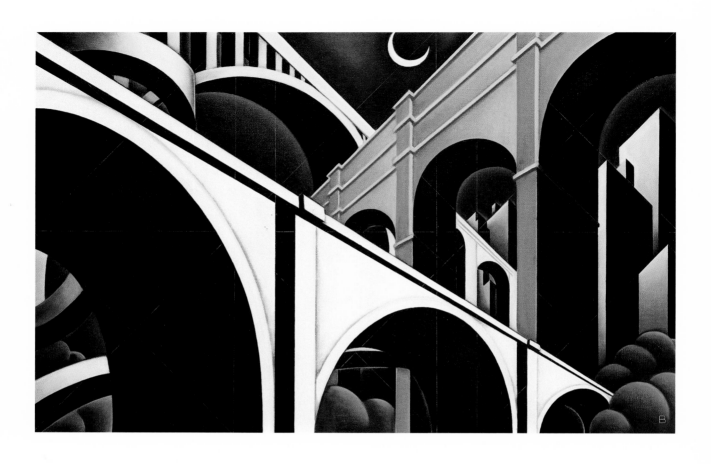

HARLEM RIVER BRIDGES I

THE BRIDGE

Good evening, here is the news.
Tonight, here in Manhattan, on a bridge,
a matter that began

two years ago between this man
and the woman next to him, is ending.
And that concludes the news for tonight,

except the old news of the river's fairy light,
and the bridge lit up
like the postcards, the cliché views,

except that they have nothing to grip the bridge with,
and across the river all the offices are on
for safety, they are like overtyped carbon

held up to light with the tears showing.
The heart that is girded iron melts. The iron
bridge is an empty party. A man is a feather.

There are too many lights on.
It's far too fanciful; that's all;
the iron rainbow to the bright water bending.

Neither is capable of going;
they stand like still beasts in a hunter's moon,
silent like beasts, but soon,

the woman
will sense in her eyes dawn's rain beginning,
and the man

feel in his muscles the river's startled flowing.

—DEREK WALCOTT

Bridges are a high point of any civilization and attract the finest minds. Although the names Gustav Lindenthal, John Roebling, Othmar Ammann, and David Steinman are not commonly known, we may equate their skills with Leonardo da Vinci's and Michelangelo's. Leonardo offered to build a masonry arch bridge over the Bosporus, with an unprecedented span of 905 feet. Michelangelo was a consultant on the Trinità Bridge in Florence. (This one was a casualty of World War II.) Like their Renaissance counterparts, New York's bridge builders were not limited in their talents. David Steinman wrote books and poetry. Gustav Lindenthal had great insight as a sociologist and economist. John Roebling was a philosopher, inventor, musician, and linguist.

"All the bridge designers I've ever met were egomaniacs," commented a Canadian professor of civil engineering. "They have to be. You see, you can never really tell whether a bridge will stand until the last bolt is put in place, the roadway completed. Until then, it's just a matter of conviction."

When one reads the writings of New York's bridge builders, one is impressed by their unshakable confidence and the range of their minds. One cannot underplay the significance of the public's faith in the bridge builder. A novelist or composer may present a poor work to the public at one time and make a spectacular comeback later on. This is hardly true of a bridge builder. If his work fails, no city or corporation will invest in his next project.

Like most structures, bridges reflect the spirit of their age. The extraordinary size and grandeur of New York's bridges are consistent with the effusive philosophy of the past age: that bigger is better and that technology can be used to serve and grace humanity.

Many of the artists, writers, and dramatists who flocked to New York have been impressed by the city's spans and have portrayed them in their works. But perhaps the bridges themselves are works of art. As Marcel Duchamp said, "The only contribution America has made to art are her plumbing and her bridges."

—SHARON REIER

HUDSON RIVERWALK

Skipping blue stones
across the surface of the river,
we watch
intersecting circles
furrow the mirrored clouds,
and near a slope
of moist leaves,
hear the bridge's
muddled hum
in thunder and rain.

Dashing for shelter
and out of the weather,
you want me as your river
burrowed into land,
I want you as my bridge,
the brace
of your towers
and cables.
In the light your lips barely move
when you say the sun will die,

girders rust, arches buckle,
piers rot. I shrug, blink.
Heat. Nothing stirs.
By the riverbank
black and purple stones
glisten as we stand.
In the shadow of the bridge,
I slip my hand into yours.
You hold on. Impending chaos
seems improbable.

—COLETTE INEZ

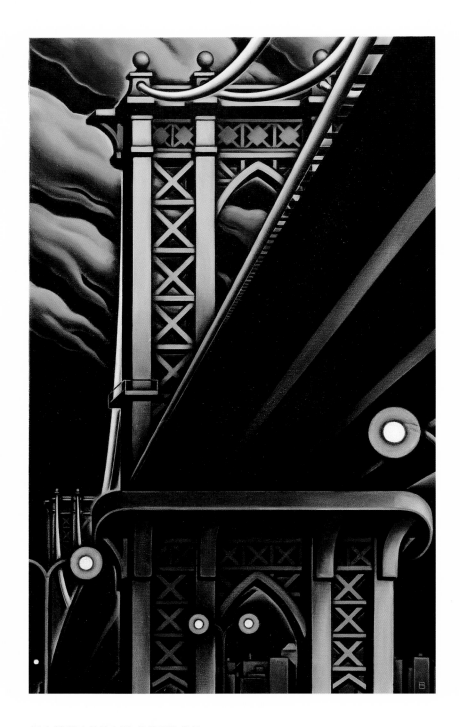

MANHATTAN BRIDGE

BRIDGES

for Bascove

Water was the first motive,
then chasms of air
we needed simply to shorten
the distance across.
And what must the light
have been like in that water
once we could linger
in the leisure of suspension?
Toppled tree, braided vine.
And below us that likeness
of a clarity we had always sought
in mind's undefined stream.

Surely the arch was first a dream,
how grace and strict economy
allows lateral stress
to be absorbed into the earth
by way of thrust,
granting thereby our suspension.
And there is too the sheer
making to consider, the bridge
of word or line
of sound, color, between
mind and world, our suspension
secured only as mind's thrust is borne.

—JAMES SEAY

MANHATTAN BRIDGE

Two turbid streams in a confluence of sun's glare.
Two muddy splashed feet and above them—a patrician head.
The Bowery, home of the Chinese theater, of bums and missions,
Canal Street, the row of cheap Jewish trade—
 Are linked and locked,
 In their screeching rush,
 By a sparkling buckle—
 The ornate portal
Of Manhattan Bridge.

Canal Street and Bowery! Sing your joy to the sky,
Roar drunkenly your glory in the cupolas of Lower Broadway,
Your pride in Woolworth, Municipal, in so many temples of business:
Shining suns for your smudged windows,
Elaborate cornices of refined riches for your poor grayness.
But above all, raise your voice in a grateful hymn
 For the joy
 Of being best men
 To Manhattan Bridge.

Manhattan Bridge!
Shall I sing your morning,
When your grand reception
Greets me with the clutter of people and wares,
With the city's jazz-symphony

In which I play too?
Shall I praise your twilight,
When the sky above you grows moody, pastoral-sentimental,
And sends a rosy-blue boyish message
To your manly might of brick and metal?
Shall I sing your night,
When in the endless chain of illuminated cars and trucks,
In the electrical lightnings at your ribs of steel,
You sparkle, tease, like a ring of monster-diamonds,
You, matchmaker of two speeding cities?

I love you, Manhattan Bridge,
More than I can sing you.
You are your own daily song,
The daring challenge, the command of success:
 Let the crooked, hooked fingers,
 Let the bought, hired hands
 Emulate Athens and Rome.
 Let them proclaim our mercantile names,
 Build a bridge to shame in beauty—
 London, Paris, Berlin.

—— A. LEYELES

ALL BRIDGES, IF THEY ARE WELL BUILT, HAVE THEIR OWN BEAUTY

All bridges, if they are well built, have their own beauty. They recall the passageway that is perhaps the most enduring symbol of life. They speak of the journey across, and they mark the limits within which we must live. At the same time they are something given to us by others, on which we cross. For we never cross entirely naked and alone, and we always rest on some base of human ingenuity provided by others.

—ALFRED KAZIN

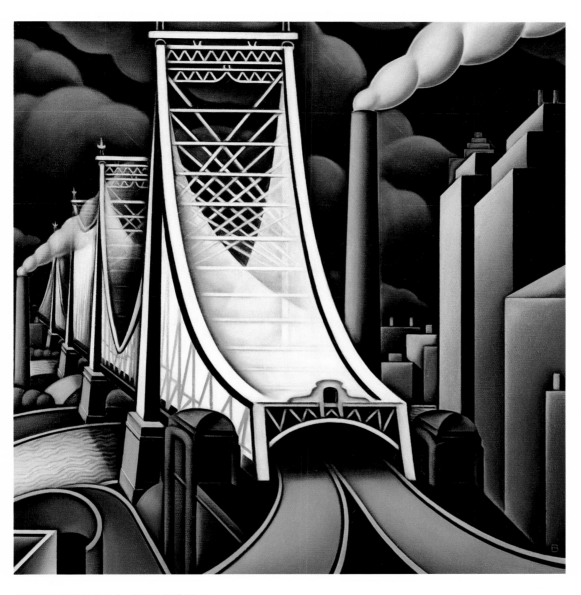

QUEENSBORO BRIDGE II

IT IS

1

a toy bridge—strings and wires—
from here: the proper side
of the river.

Off to the west, approaching,
it's a cathedral.

The sun should go down *beyond*
a river.

That's what it does
when I am at home.

2

I've recurringly dreamed the ferry's
crossing the river. I'd fall in,
swim; half-drown.

Be, now and then, lucky—
nearer one shore or another
under an unseen roadway; pull

at the thick water;
breathe again; reach,
fail to go down.

3
A thin steel arch to the west is white now,
six-o'clock metal-white sun repainted.

"But crossing a bridge to the west
leads other places!"

"Crossing a bridge to the east
('Turn quick! black in the sunset!')
is back home."

4
Did I mistake all the rides crossing,
the change of the air—*air*—
in my father and mother's car?

the palisade
gone lower and lower behind us,
blocking the sun,

later light on the hills of houses
before us
just as they are, as versus none.

The grown, swung-cable harp in between
I thought made the oldest sound.

5

It is—did I miss it?—all strings
and wires, flight of viscera, essential,
still an invention.

As who say, wartime, "How did you come to feel
so strongly?" or "War! War if you think
our side is the nothing!"

O center alone,
it *is*. Even *except* midriver, it is
provincial.

 —ELIZABETH MACKLIN

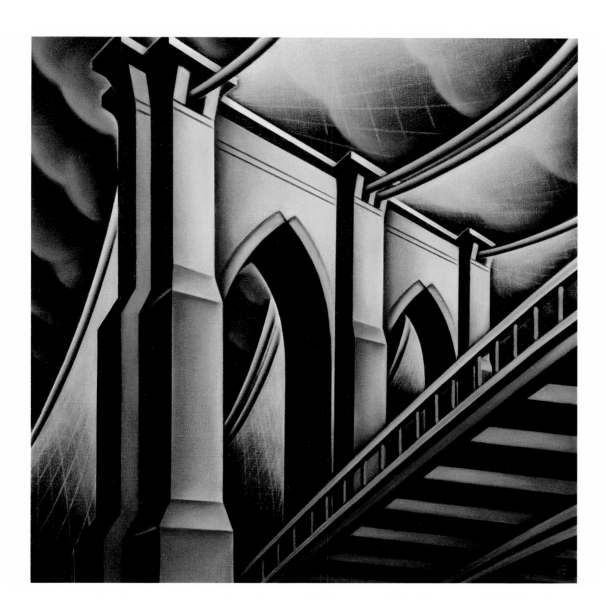

BROOKLYN BRIDGE II

GRANITE AND STEEL

Enfranchising cable, silvered by the sea,
 of woven wire, grayed by the mist,
 and Liberty dominate the Bay—
 her feet as one on shattered chains,
 once whole links wrought by Tyranny.

 Caged Circe of steel and stone,
 her parent German ingenuity.
 "O catenary curve" from tower to pier,
 implacable enemy of the mind's deformity,
 of man's uncompunctious greed
 his crass love of crass priority
 just recently
 obstructing acquiescent feet
 about to step ashore when darkness fell
 without a cause,
 as if probity had not joined our cities
 in the sea.

"O path amid the stars
crossed by the seagull's wing!"
"O radiance that doth inherit me!"
—affirming inter-acting harmony!

Untried expedient, untried; then tried;
way out; way in; romantic passageway
first seen by the eye of the mind,
then by the eye. O steel! O stone!
Climactic ornament, a double rainbow,
as if inverted by French perspicacity,
 John Roebling's monument,
 German tenacity's also;
 composite span—an actuality.

 —MARIANNE MOORE

TO BROOKLYN BRIDGE

How many dawns, chill from his rippling rest
The seagull's wings shall dip and pivot him,
Shedding white rings of tumult, building high
Over the chained bay waters Liberty—

Then, with inviolate curve, forsake our eyes
As apparitional as sails that cross
Some page of figures to be filed away;
—Till elevators drop us from our day . . .

I think of cinemas, panoramic sleights
With multitudes bent toward some flashing scene
Never disclosed, but hastened to again,
Foretold to other eyes on the same screen;

And Thee, across the harbor, silver-paced
As though the sun took step of thee, yet left
Some motion ever unspent in thy stride,—
Implicitly thy freedom staying thee!

Out of some subway scuttle, cell or loft
A bedlamite speeds to thy parapets,
Tilting there momently, shrill shirt ballooning,
A jest falls from the speechless caravan.

Down Wall, from girder into street noon leaks,
A rip-tooth of the sky's acetylene;
All afternoon the cloud-flown derricks turn. . .
Thy cables breathe the North Atlantic still.

And obscure as that heaven of the Jews,
Thy guerdon . . . Accolade thou dost bestow
Of anonymity time cannot raise:
Vibrant reprieve and pardon thou dost show.

O harp and altar, of the fury fused,
(How could mere toil align thy choiring strings!)
Terrific threshold of the prophet's pledge,
Prayer of pariah, and the lover's cry,—

Again the traffic lights that skim thy swift
Unfractioned idiom, immaculate sigh of stars,
Beading thy path-condense eternity:
And we have seen night lifted in thine arms.

Under thy shadow by the piers I waited;
Only in darkness is thy shadow clear.
The City's fiery parcels all undone,
Already snow submerges an iron year . . .

O Sleepless as the river under thee,
Vaulting the sea, the prairies' dreaming sod,
Unto us lowliest sometime sweep, descend
And of the curveship lend a myth to God.

—HART CRANE

· 65 ·

Yes: I loved the great bridges and walked back and forth over them, year after year. But as often happens with repeated experiences, one memory stands out above all others: a twilight hour in early spring—it was March, I think—when, starting from the Brooklyn end, I faced into the west wind sweeping over the rivers from New Jersey. The ragged, slate-blue cumulus clouds that gathered over the horizon left open patches for the light of the waning sun to shine through, and finally, as I reached the middle of the Brooklyn Bridge, the sunlight spread across the sky, forming a halo around the jagged mountain of skyscrapers, with the darkened loft buildings and warehouses huddling below in the foreground. The towers, topped by the golden pinnacles of the new Woolworth Building, still caught the light even as it began to ebb away. Three-quarters of the way across the Bridge I saw the skyscrapers in the deepening darkness become slowly honeycombed with lights until, before I reached the Manhattan end, these buildings piled up in a dazzling mass against the indigo sky.

Here was my city, immense, overpowering, flooded with energy and light; there below lay the river and the harbor, catching the last flakes of gold on their waters, with the black tugs, free from their barges, plodding dockward, the ferryboats lumbering from pier to pier, the tramp steamers slowly crawling toward the sea, the Statue of Liberty erectly standing, little curls of steam coming out of boat whistles or towered chimneys, while the rumbling elevated trains and trolley cars just below me on the bridge moved in a relentless tide to carry tens of thousands homeward. And there was I, breasting the March wind, drinking in the city

and the sky, both vast, yet both contained in me, transmitting through me the great mysterious will that had made them and the promise of the new day that was still to come.

The world, at that moment, opened before me, challenging me, beckoning me, demanding something of me that it would take more than a lifetime to give, but raising all my energies by its own vivid promise to a higher pitch. In that sudden revelation of power and beauty all the confusions of adolescence dropped from me, and I trod the narrow, resilient boards of the footway with a new confidence that came, not from my isolated self alone but from the collective energies I had confronted and risen to.

I cannot hope to bring back the exaltation of that moment: the wonder of it was like the wonder of an orgasm in the body of one's beloved, as if one's whole life had led up to that moment and had swiftly culminated there. And yet I have carried the sense of that occasion, along with two or three other similar moments, equally enveloping and pregnant, through my life: they remain, not as a constant presence, but as a momentary flash reminding me of heights approached and scaled, as a mountain climber might carry with him the memory of some daring ascent, never to be achieved again. Since then I have courted that moment more than once on the Brooklyn Bridge; but the exact conjunction of weather and light and mood and inner readiness has never come back. That experience remains alone: a fleeting glimpse of the utmost possibilities life may hold for man.

—LEWIS MUMFORD

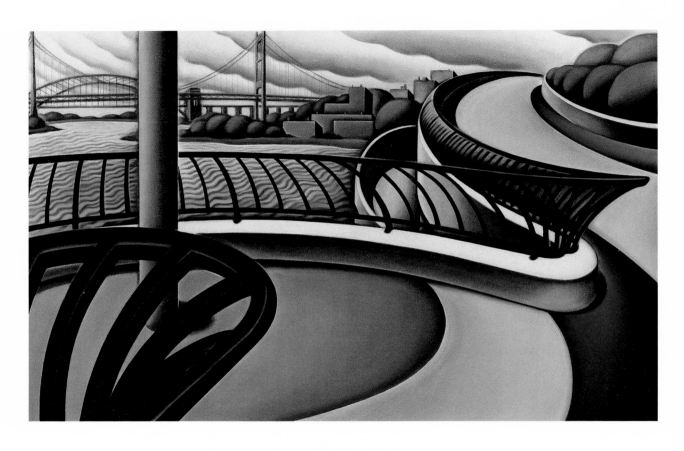

FINLEY WALK (HELL GATE & TRIBOROUGH BRIDGES)

WALKING ON WATER IN AMERICA

in remembrance of Othmar Ammann, master bridge builder

What was it like to arrive, all spit and polish, from Switzerland in 1904?
To sit on the banks of the Palisades with only a sky-colored blanket beneath you
And birds, light as epiphanies in earth-bound colors and burned paper shapes,
Spiralling above?

You had the ability to look at emptiness and see it open in front of you,
To stare at what was not yet there and to carry it in your mind. The architect's gift.
What is a bridge, after all, if not proof of this?

In 1918, when ice in the Hudson River stalled the coal ferries
From the New Jersey mines, the cold and famine killed so many.
All the rich blackness they needed lay within view but was kept from them,
Like a vision of heaven.

The hungry and cold stared at the implacable
Until they saw the boats of their wishes sailing towards them.
But when you looked at that same flat air, you saw

A mountain—only suspended.
And out of the dark mine of your own ambitions, out of mud and knowledge
And dreams made of blackness—ignitable, waiting—came our future.
Others could agitate or inspire, but they were not like you.

There was Von Karman, the "aerodynamicist" who once introduced himself as
 "representing the wind."
There were the famous Roeblings. And Lindenthal, who clothed his scaffolds in confections
 of concrete
And who fought for impossible complexity and scale.

There was handsome Goethals, the military man dressed in civies who feigned indifference
As he re-shaped the earth at the Panama Canal.
And David Steinman, who grew up poor beside the Brooklyn Bridge,
The nameless assistants, the hopeful artisans.

But I like to remember the day you were honored for your work on the George
 Washington.
When Robert Moses, master builder of public space, asked you to rise for a bow,
He forgot to mention your name.

How, when invited to appear on television, you turned to your wife and quietly asked,
"Who is Ed Sullivan?" And I like the stories about your Golden Gate Bridge.
 That it is so large, its towers are wider apart at the tops because of the curvature of the
 earth.
 That the steel of the main span contracts with such violent success it is twelve feet shorter
 in winter.

Le Corbusier called your George Washington "the most beautiful bridge in the world,"
You who remained unnamed at its opening celebration, who arrived in the 18th car
And had to be found in the crowd instead of onstage with the politicians.

"When your car moves up the ramp," he would write, "the two towers
 Rise so high that it brings you happiness: their structure is so pure,
 So resolute, so regular that here, finally, steel architecture seems to laugh."
 And yet, and yet, he loved it for the wrong reasons.

You never intended to leave the steel bare and slender, although it would become your
 trademark.
 Nor did you intend to relent in old age, surrounded, when gazing through the windows
 Of your apartment on the 32nd floor of the Carlyle Hotel, by the upside-down smiles of
 your bridges.

Through a telescope, you could survey, like sunken ships, your heavy handiwork:
 The Hell Gate, the Triborough, the Bronx-Whitestone,
 The Throgs Neck the color of pale watered silk, the Bayonne,
 And the long glittering Verrazano-Narrows, completed just before you died.

Up there, you could survey the beginning of your life as a dreamer,
 And hear, in the whine of an afternoon breeze, the voices of immigrant workers
 Locked within the cables and decks of your own creations.

You knew. You knew so early.
 Even when there were few giant bridges to cast an arched eyebrow upon the face of a river,
 To cast a steel eye into the far-reaching night.
 You knew that in the 20th century, in America, people had started to roam again,

But like birds. Driving through the thinnest, purest blue of space,
 Towards the far sides of places they'd once only imagined,
 Looking for what the world had yet to give.

—VICKIE KARP · 7 1 ·

THE GWB IN THE RAIN

Late December. Ice cold and drained of color
as fingertips cut off from oxygen.
Heading south on the Henry Hudson

the road curves, and through the vertical
tangle of tree trunks and bare branches
the idea of a bridge appears, erased

and returned by the windshield wipers.
Suspenders thin as harp strings
lift the horizontal span

to a pair of silvery catenary curves
so much the color of the day
their outlines look drawn in pencil on the sky,

the volume of each cable,
four feet in diameter and made
of enough miles of wire to crank us

halfway to the moon, reading like paper
pouring through a watercolor,
like the silence in music.

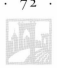

GEORGE WASHINGTON BRIDGE

Water, cliffs, sky, birds
flicker in the Xs and Vs of its bare piers
and towers, the latticed girders soaring

up and through space singing with the economy
of a poem held captive by its form, claiming
no more of the heavens and earth

than necessary to do its job.
From outside the car, the landscape's palette
of greys and browns, and our black umbrella

frame the steel bridge reaching
into the clouds draped like angel hair
on the denuded trees of the Palisades.

To anyone standing on the New Jersey side
Manhattan would look the same, the bridge's thrust
anchoring into the mists masking 179th Street,

a picture of just how real the connection
between Manhattan and America is.
To the figures on the barges plying the river,

and on the restored, two-masted brigantine
materializing under power from the white breath
of the Hudson's mouth, who see the bridge

more nearly dead on, the toy cars and trucks
skimming its motion east and west
must seem to drive off the world.

As we watch, fog claims the last trace
of the third dimension and civilization
(except for the baffled roar of traffic),

and the penciled bridge fades,
as if time had wound backward
to the blank page in Othmar Ammann's sketch pad,

leaving only the glimmer of a red lighthouse
for just such conditions, guarding Jeffrey's Point
at the bottom left-hand edge of the waterscape,

close by the downstream flank of the bridge,
an artifact from our century's childhood,
freshly painted and well maintained

as any childhood, beckoning, not even ankle high
to the bridge, barely three humans high,
its bell silenced, its lens gone.

 —MARY STEWART HAMMOND

A PLACE OF RADIANT GRACE

The George Washington Bridge over the Hudson is the most beautiful bridge in the world. Made of cables and steel beams, it gleams in the sky like a reversed arch. It is blessed. It is the only seat of grace in the disordered city. It is painted an aluminum color and, between water and sky, you see nothing but the bent cord supported by two steel towers. When your car moves up the ramp the two towers rise so high that it brings you happiness; their structure is so pure, so resolute, so regular that here finally steel architecture seems to laugh. The car reaches an unexpectedly wide apron; the second tower is very far away; innumerable vertical cables, gleaming against the sky, are suspended from the magisterial curve which swings down and then up. The rose-colored towers of New York appear, a vision whose harshness is mitigated by distance.

The bridge has a story which almost turned out ridiculously. Mr. Cullman, president of the Port of New York, told me about it. The bridge was constructed under his supervision. The problem required the utmost engineering boldness. Calculation aided by a fortunate hypothesis gave the work the severity of things which are exact. The bridge leaps over the Hudson in a single bound. Two steel-topped concrete piers between the banks and the apron hold the suspension chains. I have mentioned the extraordinary dimensions of the two towers. Constructed of riveted steel they stand up in the sky with a striking nobility. Now the towers were to have been faced with stone molded and sculptured in "Beaux-Arts" style (New York term for the aesthetic ideas current on the quai Voltaire in Paris).

Someone acted before it was too late. Then the whole committee of the Port of New York Authority. Little by little the spirit of modern times makes itself felt: these men said, "Stop! no stone or decoration here. The two towers and the mathematical play of the cables make a splendid unity. It is one. That is the new beauty." They made some calculations; the maintenance of the towers by proper painting would cost an amount equal to the interest on the capital which would have been invested in stone-faced towers. Thus the two proposals were financially equivalent. They were not looking for a means of saving expense. But "in the name of beauty and of the spirit" they dismissed the architect with his decorations. Those men are citizens!

—LE CORBUSIER

In New York from dawn to dusk to dawn, day after day, you can hear the steady rumble of tires against the concrete span of the George Washington Bridge. The bridge is never completely still. It trembles with traffic. It moves in the wind. Its great veins of steel swell when hot and contract when cold; its span often is ten feet closer to the Hudson River in summer than in winter. It is an almost restless structure of graceful beauty which, like an irresistible seductress, withholds secrets from the romantics who gaze upon it, the escapists who jump off it, the chubby girl who lumbers across its 3,500-foot span trying to reduce, and the 100,000 motorists who each day cross it, smash into it, short-change it, get jammed up on it.

Few of the New Yorkers and tourists who breeze through it are aware of the workmen riding elevators through the twin towers 612 feet above, and few people know that wandering drunks occasionally have climbed blithely to the top and fallen asleep up there. In the morning they are petrified, and have to be carried down by emergency crews.

Few people know that the bridge was built in an area where Indians used to roam, battles were fought, and where, during early colonial times, pirates were hanged along the river as a warning to other adventurous sailors. The bridge now stands where Washington's troops fell back before the British invaders who later captured Fort Lee, New Jersey, and who found kettles still on the fire, the cannon abandoned, and clothing strewn along the path of Washington's retreating garrison.

The roadway at the George Washington Bridge is more than 100 feet above the little red lighthouse that became obsolete when the bridge went up in 1931; its Jersey approach is two miles from where Albert Anastasia lived behind a high wall guarded by Doberman pinschers; its Jersey tollgate is twenty feet from where a truck driver without a license tried to drive four elephants across in his trailer—and would have if one elephant hadn't fallen out. The upper span is 220 feet from where a Port Authority guard once climbed up to tell an aspiring suicide, "Listen, you s.o.b., if you don't come down, I'm going to shoot you down"—and the man crawled quickly down.

Around the clock the bridge guards stay alert. They have to. At any moment there may be an accident, breakdown, or a suicide. Since 1931, a hundred people have jumped from the bridge. More than twice that number have been stopped. Bridge jumpers intent on committing suicide go quickly and quietly. On the edge of the roadway they leave automobiles, jackets, eyeglasses, and sometimes a note reading, "I wish to take the blame for everything" or "I don't want to live any more."

—GAY TALESE

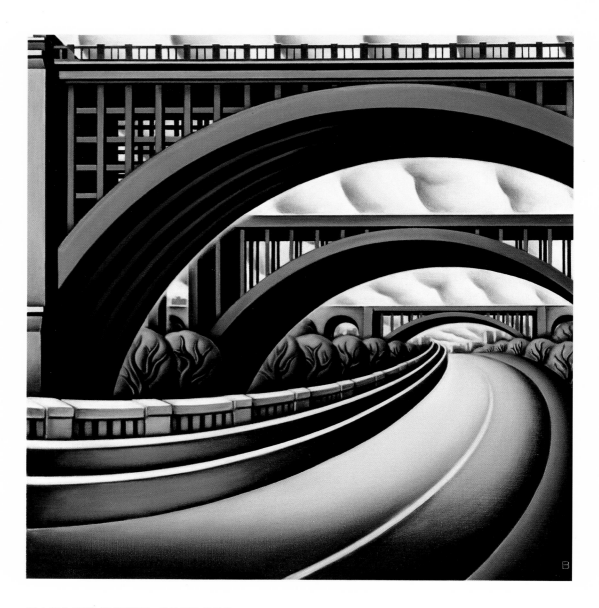

HARLEM RIVER BRIDGES II

THE FLOWER

A petal, colorless and without form
the oblong towers lie

beyond the low hill and northward the great
bridge stanchions,

small in the distance, have appeared,
pinkish and incomplete—

It is the city,
approaching over the river. Nothing

of it is mine, but visibly
for all that it is petal of a flower—my own.

It is a flower through which the wind
combs the whitened grass and a black dog

with yellow legs stands eating from a
garbage barrel. One petal goes eight blocks

past two churches and a brick school beyond
the edge of the park where under trees

leafless now, women having nothing else to do
sit in summer—to the small house

in which I happen to have been born. Or
a heap of dirt if you care

to say it, frozen and sunstreaked in
the January sun, returning.

Then they hand you—they who wish to God
you'd keep your fingers out of

their business—science or philosophy or
anything else they can find to throw off

to distract you. But Madame Lenine
is a benefactress when under her picture

in the papers she is quoted as saying:
Children should be especially protected

from religion. Another petal
reaches to San Diego, California where

a number of young men, New Yorkers most
of them, are kicking up the dust.

A flower, at its heart (the stamens, pistil,
etc.) is a naked woman, about 38, just

out of bed, worth looking at both for
her body and her mind and what she has seen

and done. She it was put me straight
about the city when I said, It

makes me ill to see them run up
a new bridge like that in a few months

and I can't find time even to get
a book written. They have the power,

that's all, she replied. That's what you all
want. If you can't get it, acknowledge

at least what it is. And they're not
going to give it to you. Quite right.

For years I've been tormented by
that miracle, the buildings all lit up—

unable to say anything much to the point
though it is the major sight

of this region. But foolish to rhapsodize over
strings of lights, the blaze of a power

in which I have not the least part.
Another petal reaches

into the past, to Puerto Rico
when my mother was a child bathing in a small

river and splashing water up on
the yucca leaves to see them roll back pearls.

The snow is hard on the pavements. This
is no more a romance than an allegory.

I plan one thing—that I could press
buttons to do the curing of or caring for

the sick that I do laboriously now by hand
for cash, to have the time

when I am fresh, in the morning, when
my mind is clear and burning—to write.
 —WILLIAM CARLOS WILLIAMS

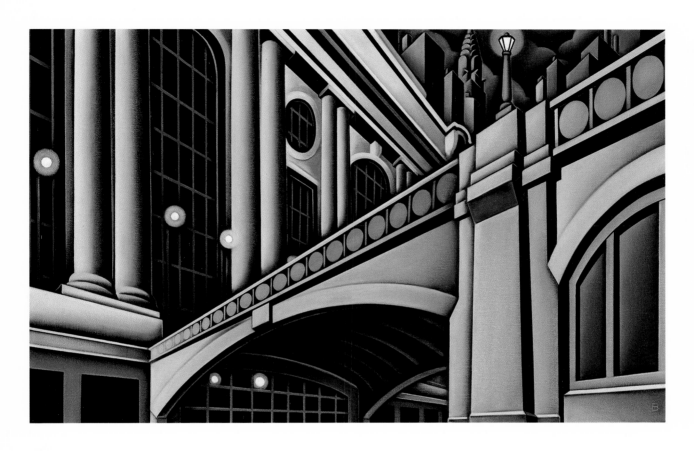

PERSHING SQUARE BRIDGE

HOW WONDERFUL IT IS THAT THE PARK AVENUE VIADUCT IS BEING REHABILITATED

How wonderful it is that the Park Avenue Viaduct is being rehabilitated
I wish I were too
now the rain is pouring down and it just makes me wet
while the particles of filthy Manhattan air
are filling in the chinks in the viaduct's reconstruction

—FRANK O'HARA

THE BRIDGE POEM

I've had enough
I'm sick of seeing and touching
Both sides of things
Sick of being the damn bridge for everybody

Nobody can talk to anybody without me Right

I explain my mother to my father my father to my little sister my
little sister to my brother my brother to the White Feminists the
White Feminists to the Black Church Folks the Black Church Folks
to the ex-Hippies the ex-Hippies to the Black Separatists the Black
Separatists to the Artists and the Artists to the parents of my
friends. . .

Then
I've got to explain myself
To everybody

I do more translating than the U.N.

Forget it
I'm sick of filling in your gaps
Sick of being your insurance against
The isolation of your self-imposed limitations

Sick of being the crazy at your Holiday Dinners
The odd one at your Sunday Brunches
I am sick of being the sole Black friend to
Thirty-four Individual White Folks

Find another connection to the rest of the world
Something else to make you legitimate
Some other way to be political and hip
I will not be the bridge to your womanhood
Your manhood
Your human-ness

I'm sick of reminding you not to
Close off too tight for too long

Sick of mediating with your worst self
On behalf of your better selves

Sick
Of having
To remind you
To breathe
Before you
Suffocate
Your own
Fool self

Forget it
Stretch or drown
Evolve or die

You see it's like this
The bridge I must be
Is the bridge to my own power
I must translate
My own fears
Mediate
My own weakness

I must be the bridge to nowhere
But my own true self
It's only then
I can be
Useful

—KATE RUSHIN

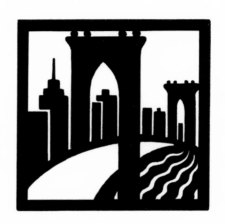

LIST OF THE PAINTINGS

Paintings photographed by D. James Dee.

ABOUT THE PAINTER

Born in 1946, Bascove studied at the Philadelphia Museum College of Art from 1964 to 1968. She has worked with publishing houses worldwide since her graduation, providing cover art for such literary figures as Robertson Davies, Jerome Charyn, and T. Coraghessan Boyle. For more than a decade her paintings have been exhibited regularly in New York and Paris. Her work can be found in the collections of the Museum of the City of New York, Time Warner, and the Musée de Cherbourg. She presently makes her home in New York City with her husband, architect Michael Avramides, and a number of cats and dogs named after various literary figures for which they have absolutely no corresponding attributes.

STONE AND STEEL

has been set in Fournier, an elegant and deliberately "artistic" typeface derived from the eighteenth-century designs of Pierre Simon Fournier, known to typographic admirers as Fournier le jeune. Fournier was a prolific and accomplished designer—not only of typefaces but also of script, musical notation, vignettes, and decoration. His accomplishments can be best seen in his *Manuel Typographique*, published in two volumes between 1764 and 1766. At the same time, he operated a typefoundry offering a wide array of ornamental letters, initial letters, decorated dashes and braces, as well as a broad selection of printers' ornaments, decorative designs cast in a single piece of metal that could be fit together to form borders, cartouches, and tailpieces in almost endless variety. His types stand with those of Baskerville and Bodoni as paradigms of eighteenth-century typographic sensibility. They are sharply drawn and bear clear traces of both the engravers burin and the Enlightenment. Their stresses are horizontal and the set width is narrow. Like the books they so frequently illustrated, these are types that "sparkle": since their first use in France's golden age of illustration, they have always been associated with artists' books.

Stone and Steel was designed by Bascove, Godine, and Gordy.